Your name is _____

My name is _Marc_

Now we are friends.

this is the

FIRST PAGE

Isn't it lovely?
Let's not put
anything else here.

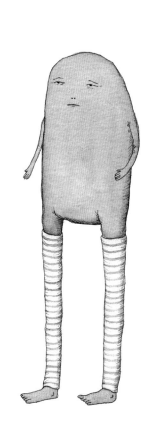

Marc Johns Serious Drawings

teNeues

Introduction
↓

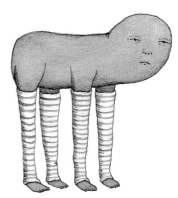

FUCK ART. Let's Be Hedge Fund Managers. Scrawled on a 3"×3" yellow sticky note, it reads like a demented daily reminder: Pick up milk, wash car, go to dentist—and, oh, yes, before I forget: abandon aesthetic pursuits in favor of a life spent acquiring vast amounts of wealth.

Fuck Art was the first drawing I ever saw by Marc Johns. It struck me as much for the choice of material—so efficient, so disposable, so pleasingly sticky—as it did for its mordant humor. And he had dozens of them, visual non-sequiturs, painted on stickies, that reveal a surreal world of talking underwear, walking bicycles and pie charts that quantify "that which is relevant" and "that which is not." Not to mention the screaming, bright pink square that urgently intones, *UP THE DOSAGE.* In these troubled times, sage advice, indeed.

The sticky notes were a fine introduction to the rest of his work: stark illustrations, in modest sizes, neatly composed in ink and watercolor—most of which feature a humorously-rendered pantheon of extraordinary beings and phenomena. Strange things happen in Marc Johns's world. A potato-like creature stands idly about, clad in nothing but a pair of hipster leggings. A running man is chased by a flock of floating moustaches. And a pair of men's underwear decamps to Starbucks for an afternoon caramel latté. The situations regularly veer into the absurd.

In their style, the drawings represent a color-friendly update to the dark, Victorian manner of celebrated illustrator Edward Gorey. In true turn-of-the-last-century fashion, Johns's figures are stoic and fastidious. They wear ties and overcoats and cardigans, buttoned all the way to the top. And they never lose their inscrutable gazes, even as they sprout antlers and burst into flames. The color palate, however, is far more modern. Figures are surrounded by abstract backdrops, painted in eggshell hues of pink, yellow and sky blue that make the characters—and the unusual situations they find themselves in—feel buoyant and whimsical, even when they're not.

As much as his drawings recall the visual fustiness of bygone eras, the content is frequently preoccupied with the obsessions of our age: consumerism, celebrity culture, the environment, and religion. In one illustration, jars of holy water are advertised in both 8- and 16-oz. sizes. In another, four symmetrically-arranged lightning bolts are touted as a *Wrath (4 Pack)*—leaving the viewer to imagine a Costco for higher beings. One piece, painted in a fertile, rose-pink wash, displays, in tidy rows, "famous people's teeth." Celebrities: their molars are just like ours. It is comically morbid. But not entirely unimaginable.

The drawings also serve as a catalogue of Johns's idiosyncratic obsessions: two-headed people, antlers, birds, beards, and enough luxuriant mustaches to make Teddy Roosevelt and the Rough Riders proud, all interacting nonchalantly in an alternate universe where sandpipers ride skateboards and rooms grow hair. These wry-yet-simple pieces—not quite paintings, not quite cartoons—are a serene antidote to contemporary creative life, which seems terminally afflicted by over-wrought, look-at-me antics. They are pictures of daydreams. Often fleeting. Always eccentric. Never dull. *Carolina A. Miranda*

FUCK ART. Let's Be Hedge Fund Managers [Scheiß auf die Kunst. Wir könnten doch Hedge-Fonds-Manager sein]. Diese Worte wurden auf einen 8 x 8 cm großen Klebezettel gekritzelt und erinnern an eine Gedächtnisstütze für tägliche Erledigungen: Milch kaufen, Auto waschen, zum Zahnarzt gehen, und ach ja, bevor ich es vergesse: Auf Ästhetik können wir zugunsten eines Lebens verzichten, das mit der Anhäufung großer Reichtümer verbracht wird.

Fuck Art war die erste Zeichnung, die ich jemals von Marc Johns sah. Sie erregte meine Aufmerksamkeit nicht nur wegen des verwendeten Materials – so effizient, so wegwerfbar und so angenehm haftend – sondern auch wegen des beißenden Humors. Und er hatte Dutzende davon, visuelle, auf Klebezettel gemalte unlogische Schlussfolgerungen, die eine surreale Welt sprechender Unterwäsche, gehender Fahrräder und Tortendiagramme offenlegen, die quantifizieren, „was relevant" und „was irrelevant" ist. Nicht zu vergessen ist das Quadrat in grellem Pink mit dem dringenden Hinweis *UP THE DOSAGE* [Dosis erhöhen]. In diesen problematischen Zeiten ist dies ein wahrlich weiser Rat.

Die Klebezettel waren eine hervorragende Einführung zum Rest seiner Arbeit: schlichte Illustrationen in moderaten Größen, ordentliche Kompositionen in Tinte und Wasserfarben; auf den meisten sind humorvoll dargestellte Ansammlungen außergewöhnlicher Geschöpfe und Phänomene zu sehen. In der Welt von Marc Johns passieren merkwürdige Dinge. Ein einer Kartoffel ähnelndes Geschöpf, das lediglich Hipster-Leggings trägt, steht betätigungslos herum. Ein rennender Mann wird von einer ganzen Armada schwebender Schnurrbärte verfolgt, und die Unterhosen eines Mannes verschwinden zu Starbucks, um dort einen Nachmittag bei Caramel Latté zu verbringen. Die Situationen gleiten stets ins Absurde ab.

Auf ihre Art sind die Zeichnungen eine farbenfrohe Version der düsteren Darstellungen im viktorianischen Stil des berühmten Illustrators Edward Gorey. Getreu der Manier der letzten Jahrhundertwende sind Johns Figuren stoisch und pingelig. Sie tragen Krawatten und bis nach oben hin zugeknöpfte Mäntel und Strickjacken. Auch wenn ihnen Geweihe wachsen und sie in Flammen aufgehen, verlieren sie nie ihren undurchdringlichen Ausdruck. Die Farbpalette ist jedoch viel moderner. Die Figuren sind vor einem abstrakten Hintergrund in rosa, gelben und himmelblauen Farben zu sehen, in Tönen, die fürs Eierfärben verwendet werden. Dies lässt die Charaktere und die ungewöhnlichen Situationen, in denen sie sich befinden, auch dann vital und neckisch erscheinen, wenn dies nicht der Fall ist.

Seine Zeichnungen rufen die visuelle Muffigkeit vergangener Zeiten in Erinnerung, während sich der Inhalt oftmals mit den Manien unserer Zeit befasst: Konsumdenken, die Verehrung von Berühmtheiten, Umwelt und Religion. In einer Illustration wird für Weihwasser in Viertel- und Halbliterbehältern geworben. Auf einer anderen Darstellung sind vier symmetrisch angeordnete Blitze und die Bildunterschrift *Wrath (4 Pack)* [*Wut (Viererpack)*] zu sehen. Dem Betrachter ist es dann überlassen, sich einen Einkaufsmarkt für höhere Wesen vorzustellen. Auf einer Illustration sind „die Zähne berühmter Leute" ordentlich auf rosa Hintergrund aufgereiht. Berühmtheiten: Eure Backenzähne sind genauso wie die unseren. Es ist auf komische Weise morbid, jedoch nicht völlig unvorstellbar.

Die Zeichnungen dienen außerdem als Katalog für Johns idiosynkratische Manien: Menschen mit zwei Köpfen, Geweihe, Vögel, Bärte und genug üppige Schnurrbärte, um in Teddy Roosevelt und der berühmten Kavallerietruppe Rough Riders Stolz hervorzurufen, und in einem anderen Universum, in dem Strandläufer auf Skateboards fahren und Zimmern Haare wachsen, interagieren alle mit Nonchalance. Diese humoristischen, jedoch einfachen Werke, die irgendwo zwischen Gemälden und Cartoons angesiedelt sind, sind ein ruhiger Gegenpol zum zeitgenössischen kreativen Leben, das permanent unter überzeichneten, ichbezogenen Mucken zu leiden scheint. Dies sind Abbildungen von Tagträumen, die oftmals vergänglich, immer exzentrisch und nie langweilig sind. · ***Carolina A. Miranda***

FUCK ART. Et si on gérait des fonds à risque. Gribouillés sur des petits carrés jaunes autocollants de 8 cm × 8 cm, ça se lit comme un pense-bête quotidien dément : prendre du lait, laver la voiture, aller chez le dentiste et, ah oui, avant que je n'oublie : abandonner les recherches esthétiques pour une vie consacrée à acquérir d'immenses richesses matérielles.

Fuck Art fut le premier dessin que j'ai vu de Marc Johns. Il m'a frappé tant par le choix du matériel, tellement efficace, tellement jetable, si agréablement collant, que par son humour mordant. Et il en avait des douzaines, des illogismes visuels peints sur des papiers autocollants qui révèlent un monde de sous-vêtements parlant, des bicyclettes qui marchent et des diagrammes qui quantifient « ce qui est

à propos » et « ce qui ne l'est pas. » Sans parler du carré rose bonbon criard et qui vous annonce qu'il est urgent de, *RENFORCER LA DOSE*. Par ces temps troublés, c'est vraiment avisé.

Les notes autocollantes furent une bonne introduction pour le reste de son travail : des illustrations saisissantes de taille modeste, avec une composition très nette à l'encre et aquarelle, dont la plupart représente un panthéon humoristique d'êtres et phénomènes extraordinaires. Il se passe des choses étranges dans le monde de Marc Johns. Un personnage qui ressemble à une pomme de terre reste là les bras croisés, vêtu seulement d'un caleçon taille-basse. Un homme qui court est pourchassé par une flopée de moustaches flottantes. Et des sous-vêtements pour homme décampent à Starbucks pour un latté au caramel l'après-midi. Les situations ne manquent pas de glisser dans l'absurde.

Le style de ces dessins représente une actualisation toute en couleurs par rapport au style victorien du célèbre illustrateur, Edward Gorey. Fidèle à la mode de la fin du siècle dernier, les personnages de John sont stoïques et méticuleux. Ils portent des cravates et des manteaux et des vestes, tout boutonnés du haut en bas. Et ils ne perdent jamais leur regard énigmatique, même lorsqu'ils leur poussent des bois de cerf et qu'ils commencent à partir en flammes. Mais la palette de couleurs est bien plus moderne. Les personnages sont entourés par des arrière-plans abstraits, peints d'un ton blanc cassé avec du rose, du jaune et du bleu qui donnent l'impression que les personnages et les situations inhabituelles dans lesquelles ils se trouvent sont allègres et fantasques, même si ce n'est pas le cas.

Si ses dessins rappellent visuellement des époques révolues, le contenu renferme des préoccupations avec des obsessions bien de notre âge : le consumérisme, le culte des célébrités, l'environnement et la religion. Dans une illustration, on trouve une publicité pour des flacons d'eau bénite de 8 et 16 onces. Dans une autre, quatre éclairs disposés de façon symétrique sont appelés la *Colère (Paquet de 4)*, ce qui laisse au spectateur imaginer un magasin Costco pour des êtres supérieurs. Une autre pièce peinte au lavis dans un ton de rose, montre des rangées nettes de « dents des célébrités. » Leurs molaires sont en fait comme les nôtres. C'est d'un comique morbide mais pas complètement inimaginable.

Les dessins jouent aussi le rôle d'un catalogue des obsessions particulières de Johns : des personnages à deux têtes, des bois de cerf, des oiseaux, des barbes et des moustaches touffues en quantité suffisante pour faire la fierté de Teddy Roosevelt et des Rough Riders. Tous agissent avec nonchalance dans un univers parallèle où les bécasses font du skateboard et les chambres ont des cheveux qui poussent. Ces œuvres narquoises mais simples, ne sont pas tout à fait des peintures, pas tout à fait des caricatures, plutôt un antidote serein contre la créativité de la vie contemporaine qui semble définitivement affligée par des attitudes m'as-tu-vu et au bord de la crise de nerf. Ici il s'agit de rêves éveillés. Souvent fugaces, parfois excentriques mais jamais ennuyeux. ***Carolina A. Miranda***

Serious Drawings on regular paper

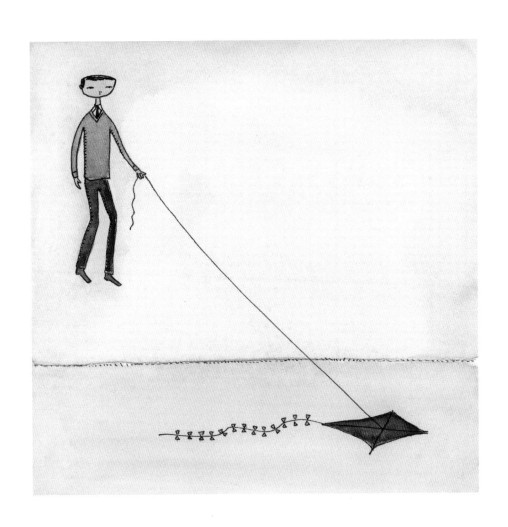

GLOVES

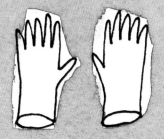

NOW WITH 20%
MORE FINGERS

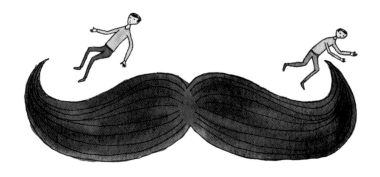

this mustache is dangerous

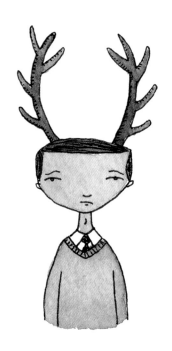

He had heard
that antlers
were in vogue

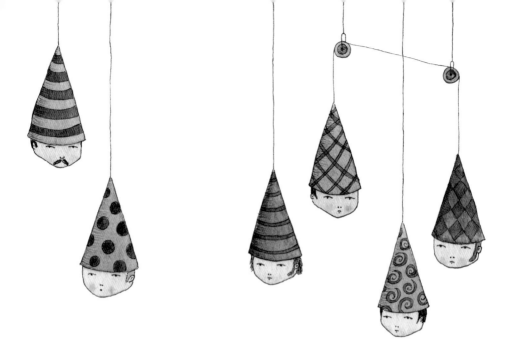

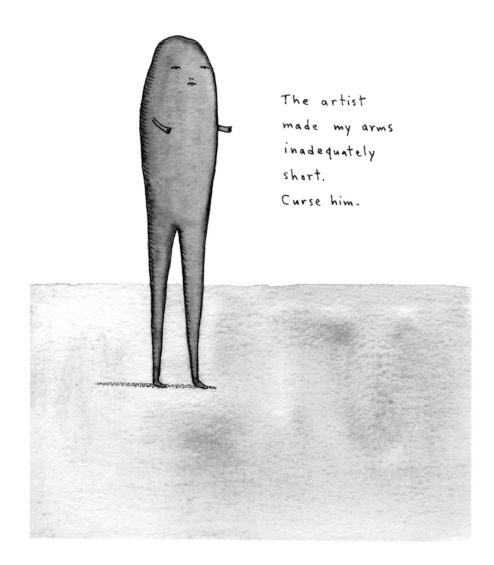

The artist
made my arms
inadequately
short.
Curse him.

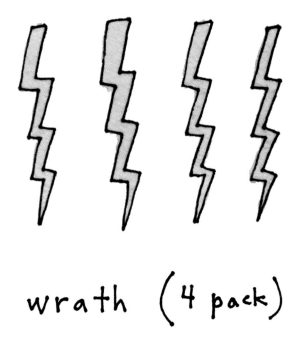

wrath (4 pack)

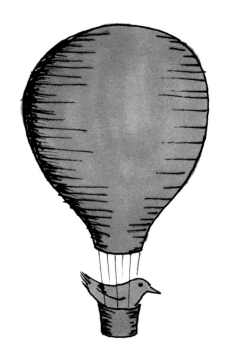

After years of flapping his wings,
Jeffrey was fed up and decided to
try something else.

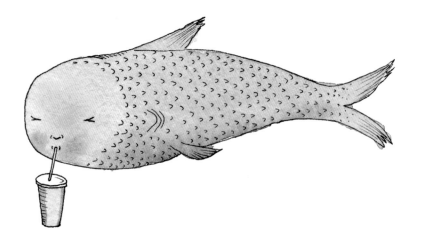

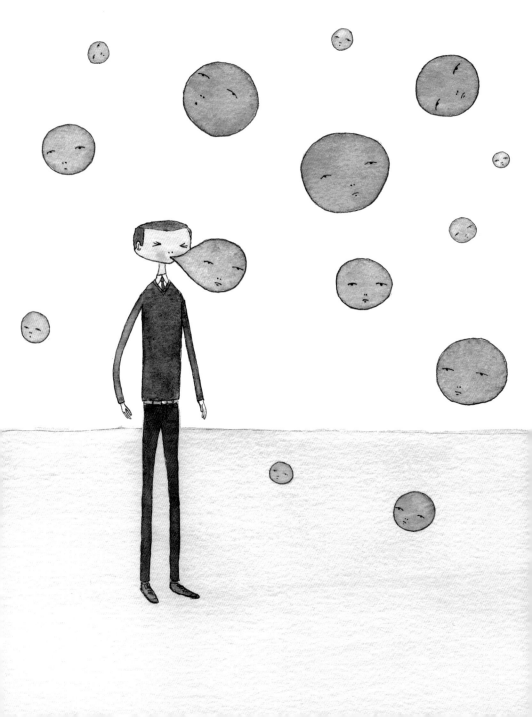

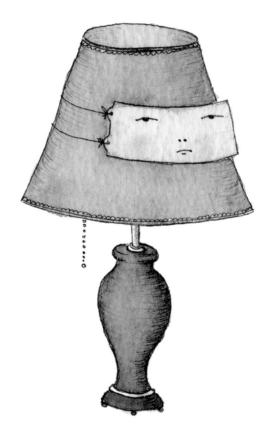

this lamp is wearing
a mask.

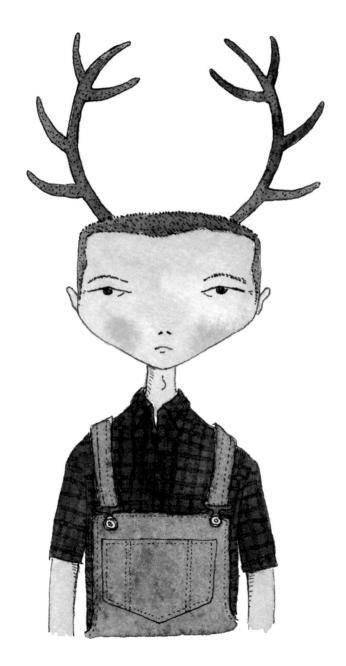

Jim tries harder.

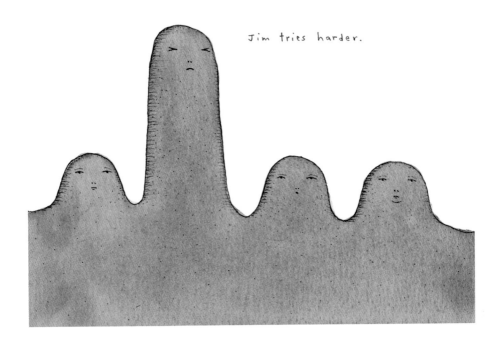

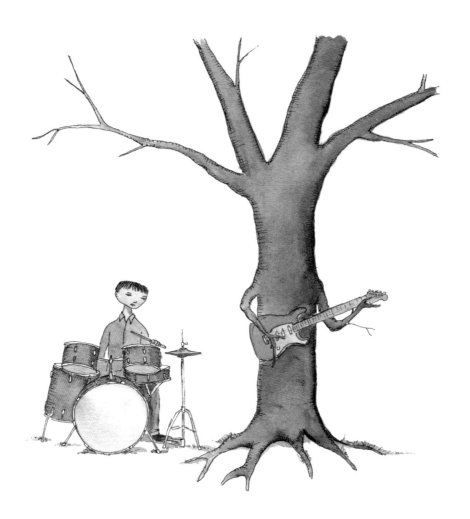

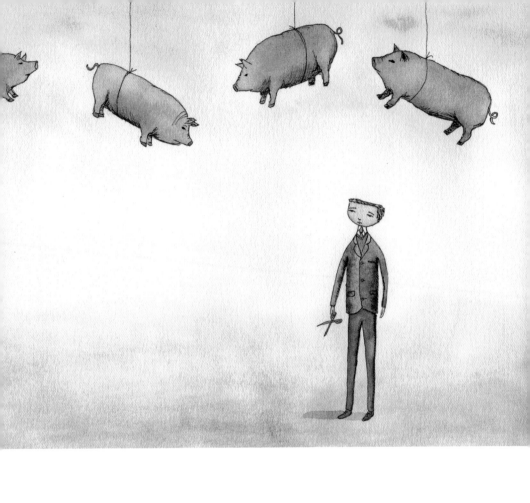

jars with beards

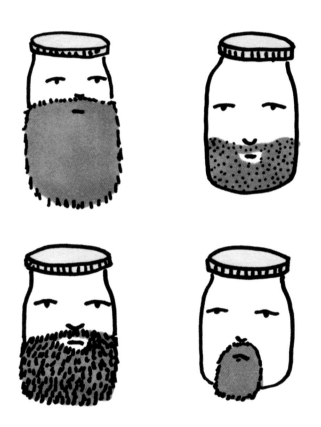

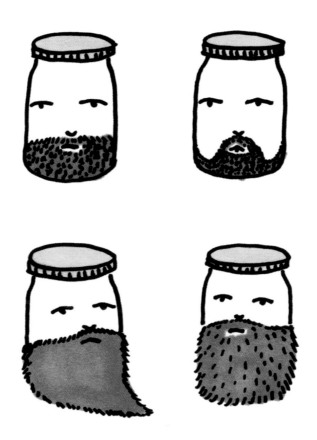

BE NICE TO
CHICKENS

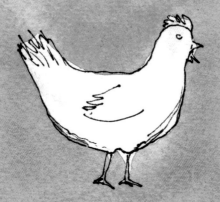

YOU MAY ALSO EAT THEM.
(THEY ARE CHICKENS, AFTERALL)

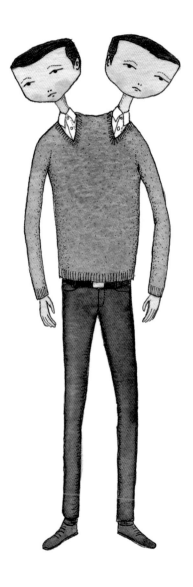

SHIPLEY & CROSS

FINE KNIT
WOOL SWEATERS

FOR TWO-HEADED
MEN OF ALL
AGES & SIZES

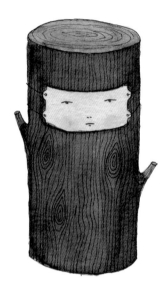 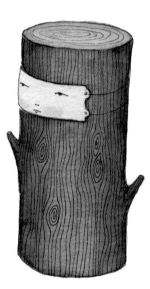

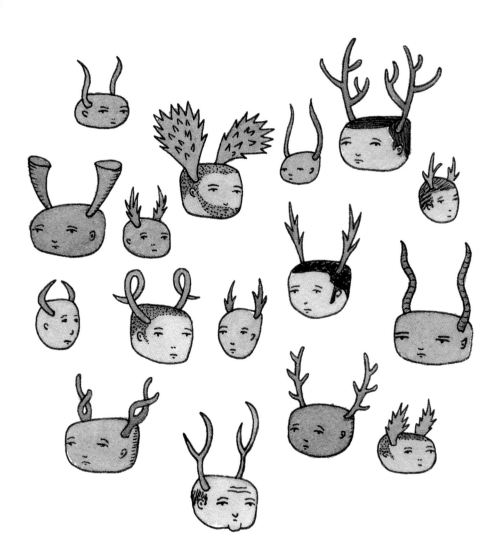

31

He had the
remarkable ability
to hover —
as long as he left
behind his shoes.

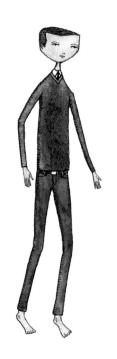

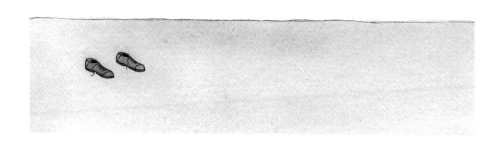

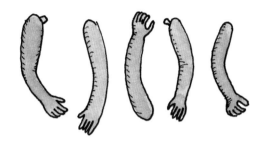

These are doll arms.
They are not meant to
convey some sort of
morbid arty statement.
They are just doll arms.

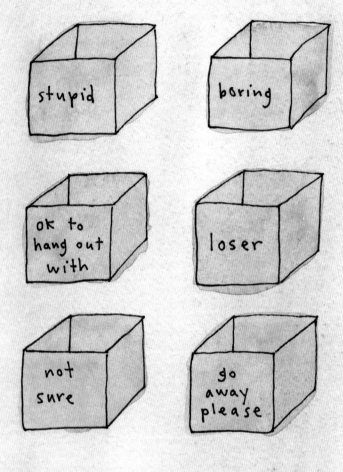

the boxes we put people in.

He thought the extra arms
would make him more productive.

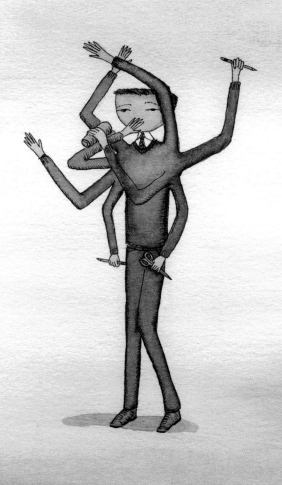

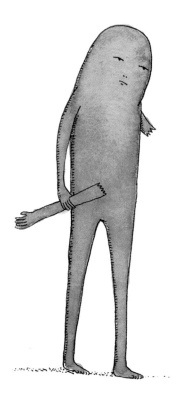

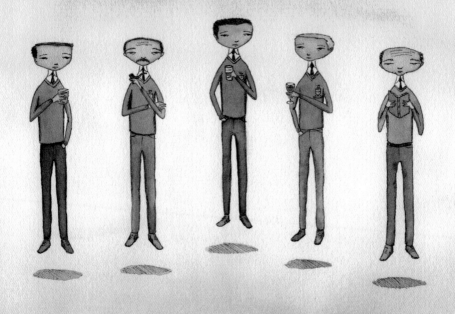

The Hovering Gentlemen's Club

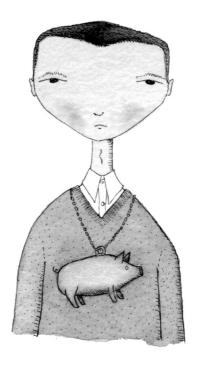

It was his understanding that the lucky pig charm would ward off evil spirits, remove curses and bring great wealth into his life.

BEARD BIRD

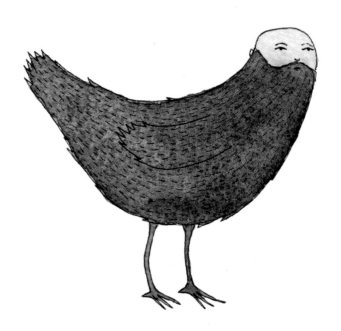

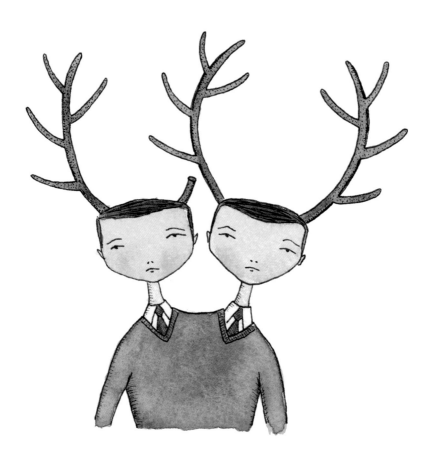

His sweater gave him the
power to ward off his foes.

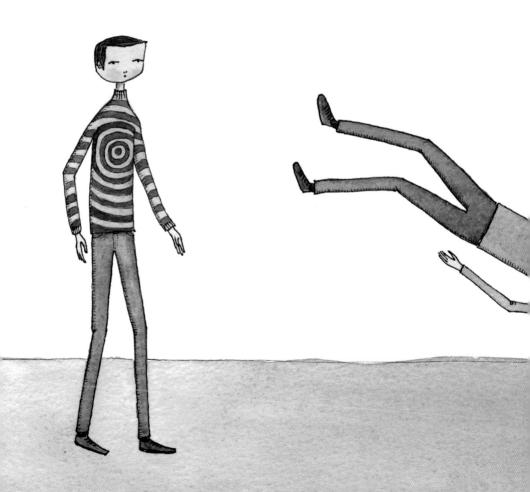

I like my

ARTSY

with a

little bit of

FARTSY

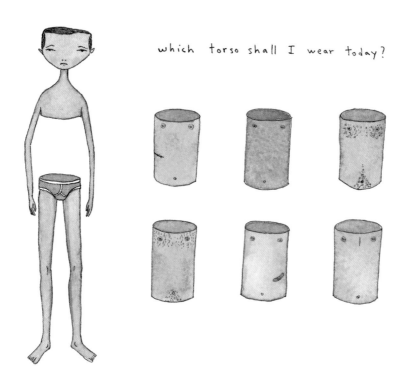

which torso shall I wear today?

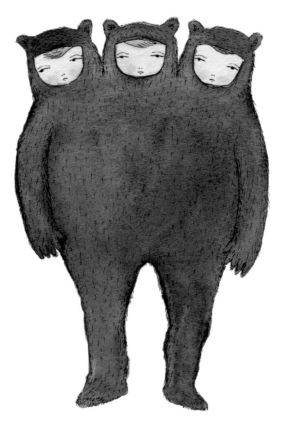

They make bear suits for three-headed people now.

famous people's teeth

we enjoy dressing up as birds.

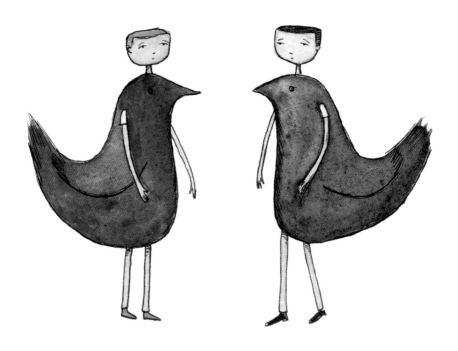

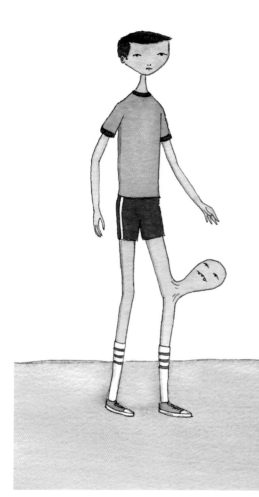

He did not like
the creature
that was growing
out of his knee,
but he was too shy
to ask him to
leave.

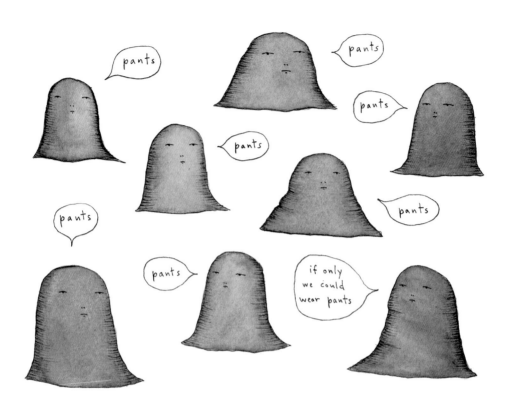

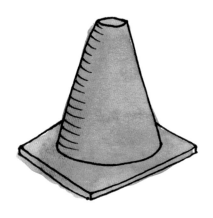

I would
hate to be
reincarnated
as a traffic
cone.

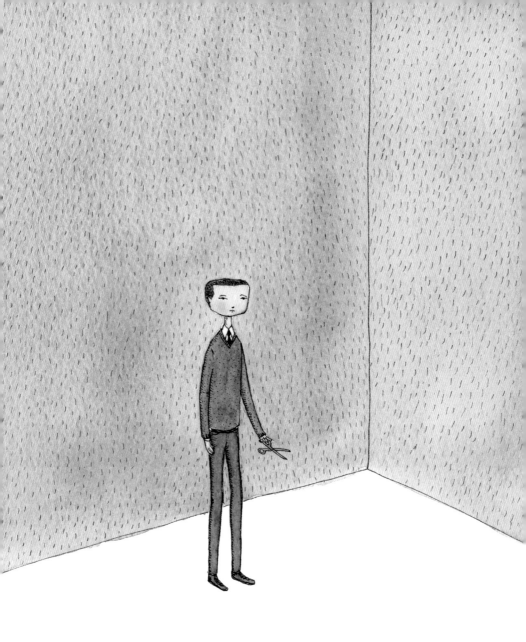

this room is hairy.

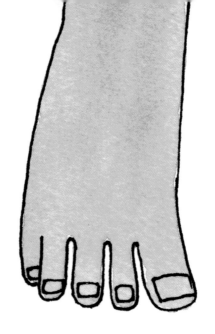

Inside my shoes, my toes fight for personal space. The smallest always loses.

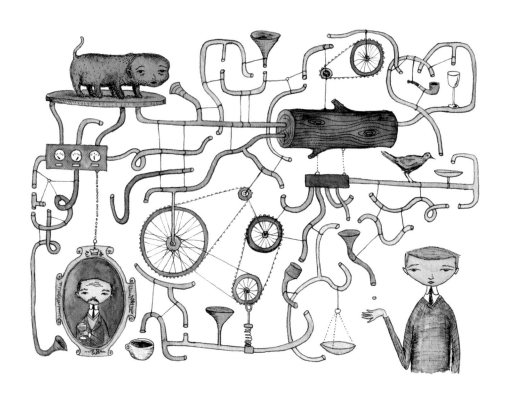

do not discard
this severed hand.
it is mine.
i plan on
reattaching it.

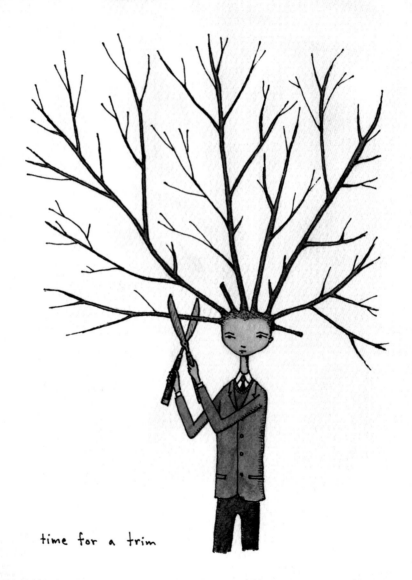

time for a trim

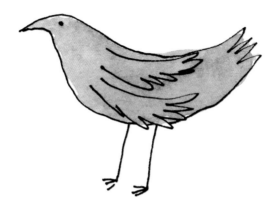

he could not fly
very well because
he had two
left wings.

we enjoy leggings

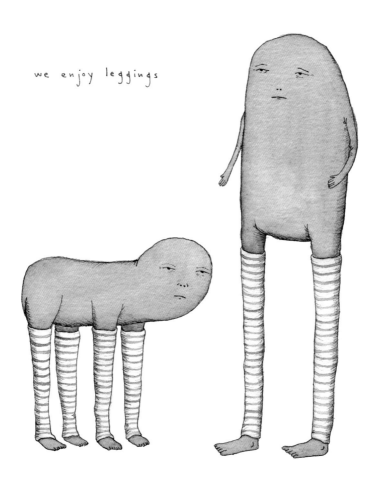

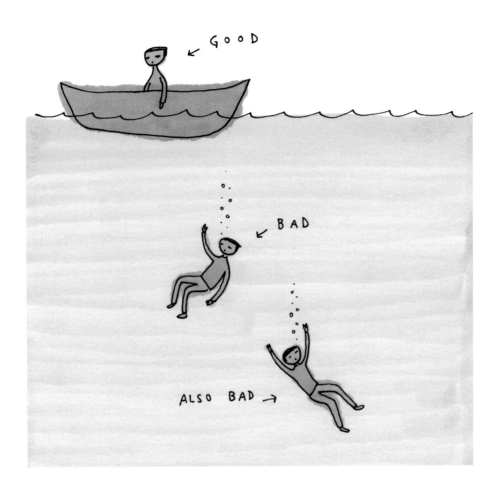

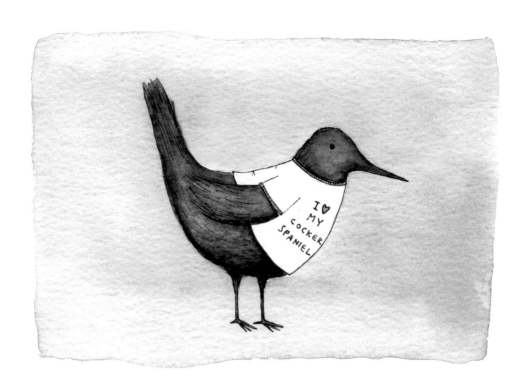

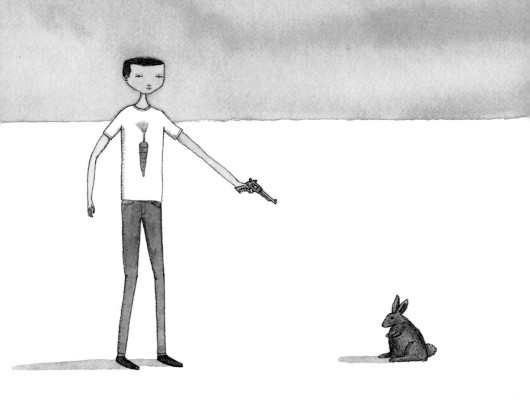

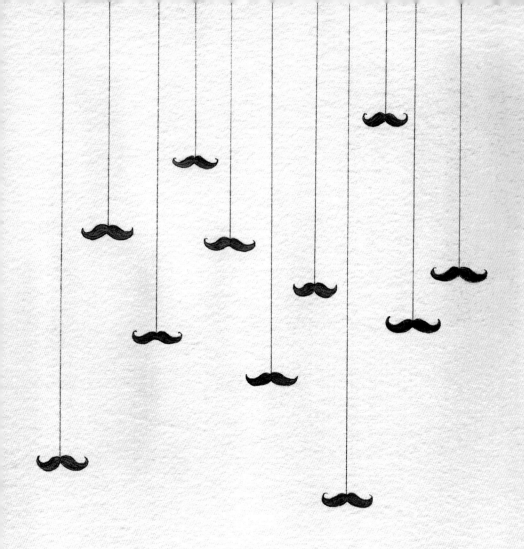

mustaches on strings are the finest of things

no one knew
what was
underneath
his cape.

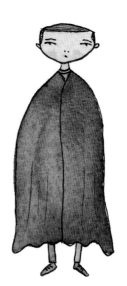

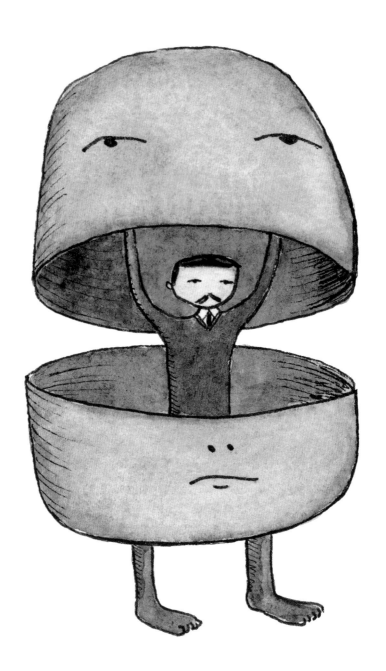

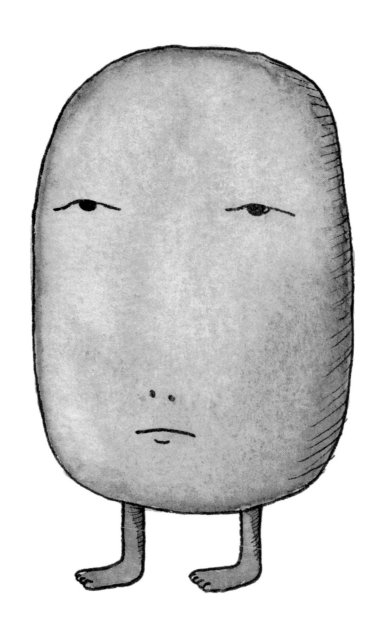

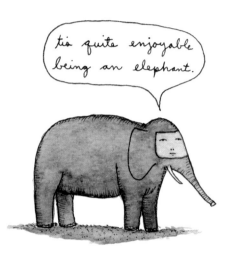

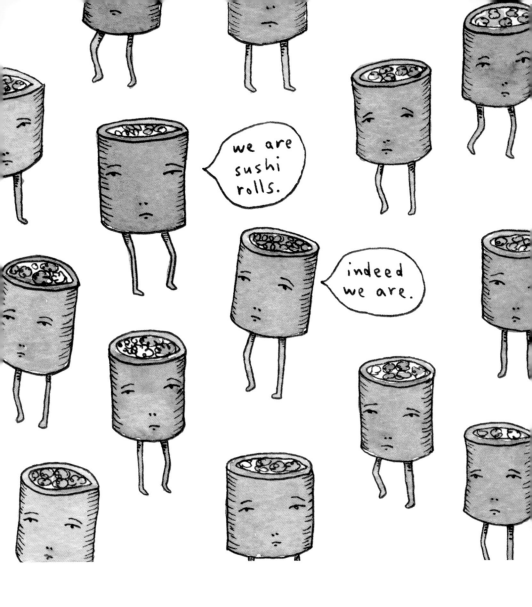

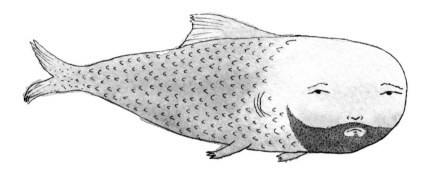

He thought the extra legs
would help him go faster.

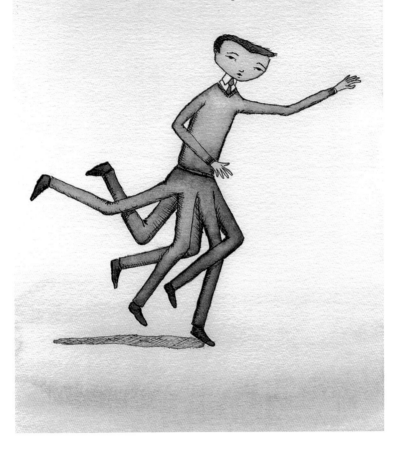

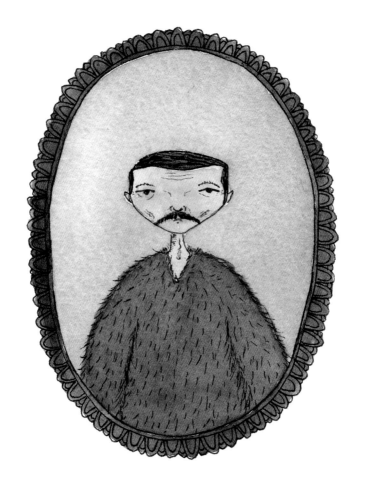

After losing his wife to Cholera,
Mr. Dwindelworth had a sweater
made from her hair and wore it
every day for a year.

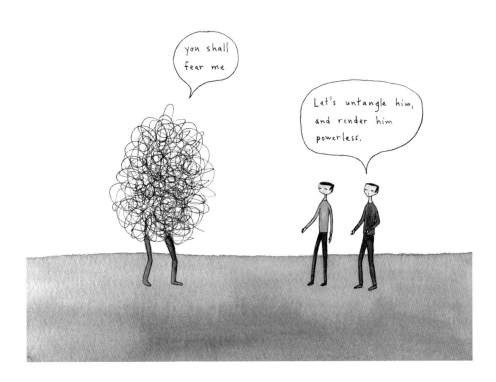

six people who never
get invited to dinner parties.

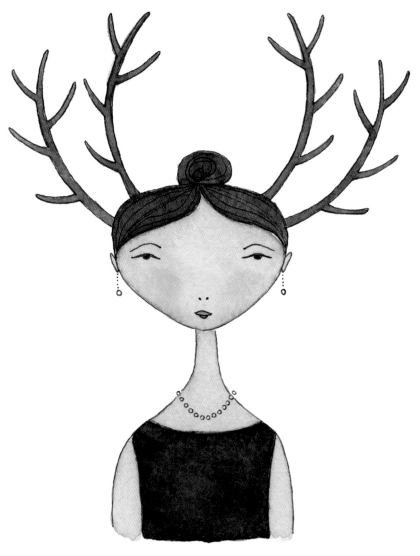

Mrs. Van der Woodsen was
particularly fond of antlers

HOLY WATER

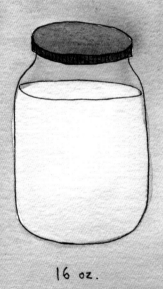

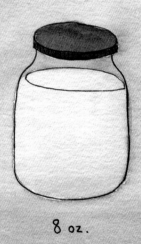

16 oz.

8 oz.

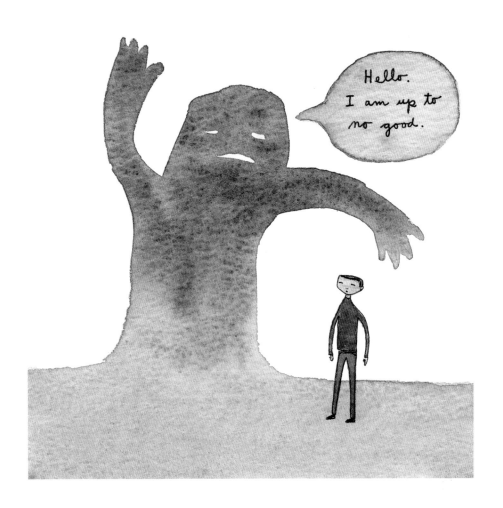

73

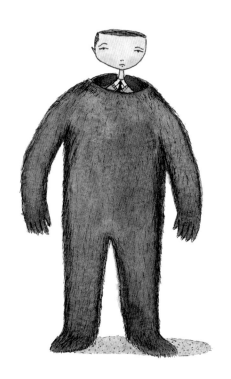

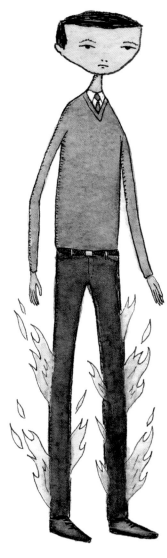

LIAR

UNBEKNOWNST *

* Isn't that a great word?
It's a bit funny looking, when
you take a good look at it.
I mean, look at all those
consonants at the end.

If I had arms, I would
play mad freakin' beats.

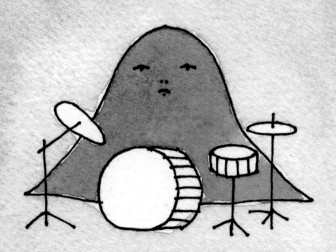

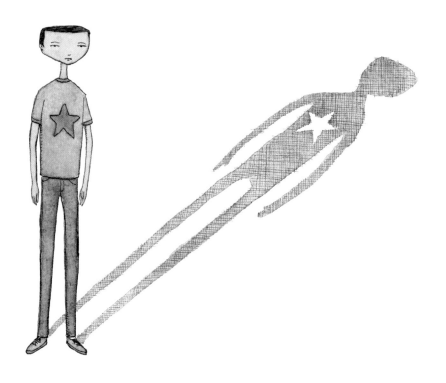

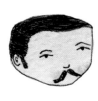 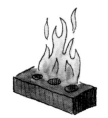 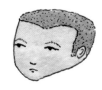

Man #1 Man #2

Man #1 : I have the power to
 set bricks on fire.

Man #2 : What is your secret?

Man #1 : I eat pretzels and hum
 Swedish lullabies.

Man #2 : Swedish lullabies?

Man #1 : They are more effective
 than other lullabies.

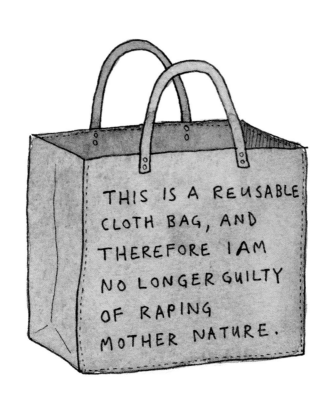

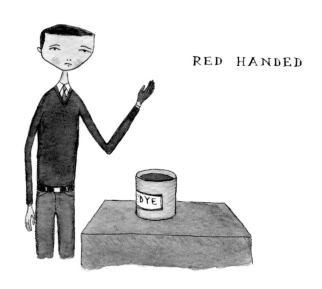

RED HANDED

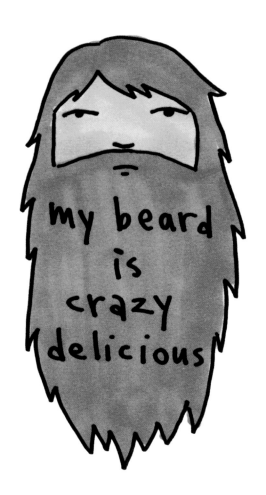

THE WORLD

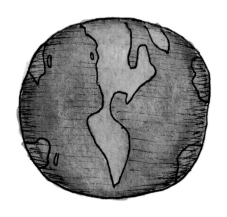

ingredients:

mostly idiots.

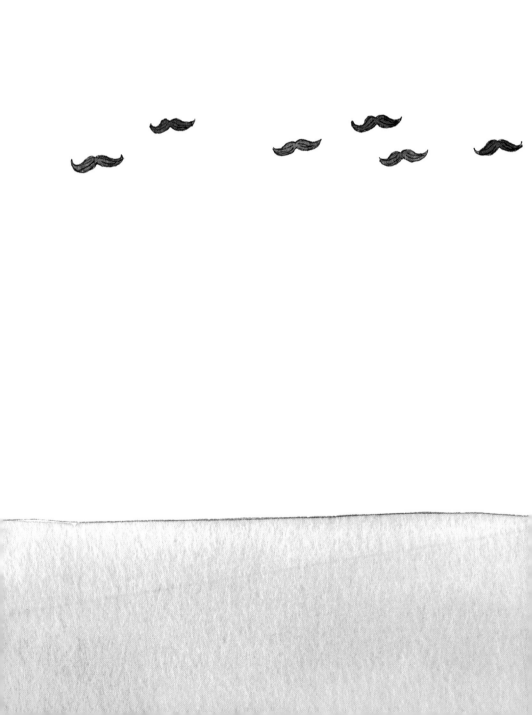

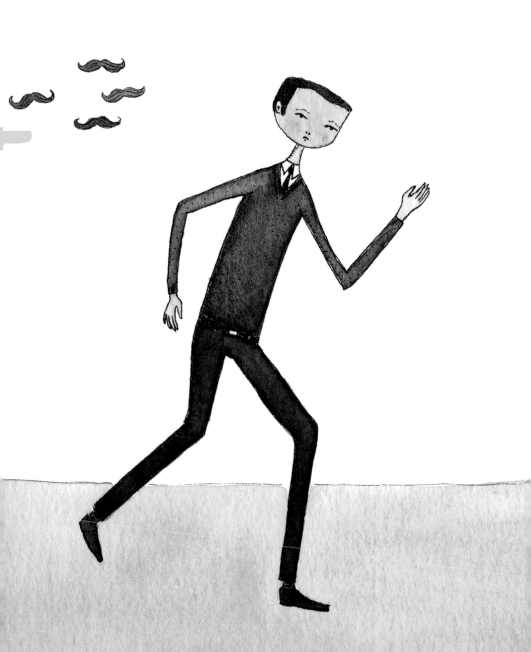

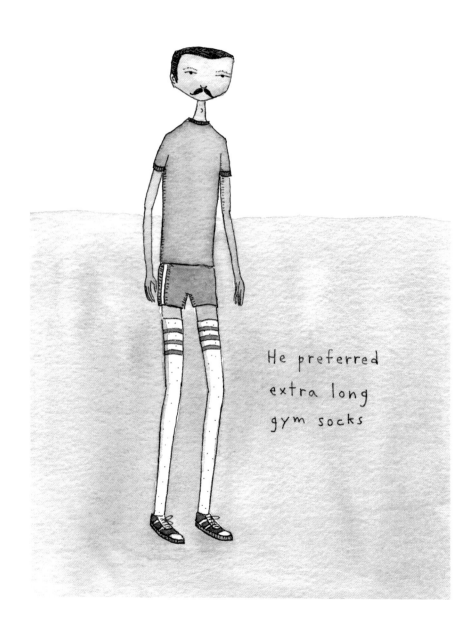

He preferred
extra long
gym socks

sometimes while I'm at
work, my underpants sneak
out of the house to spend
the afternoon at starbucks
and sip on caramel lattés.

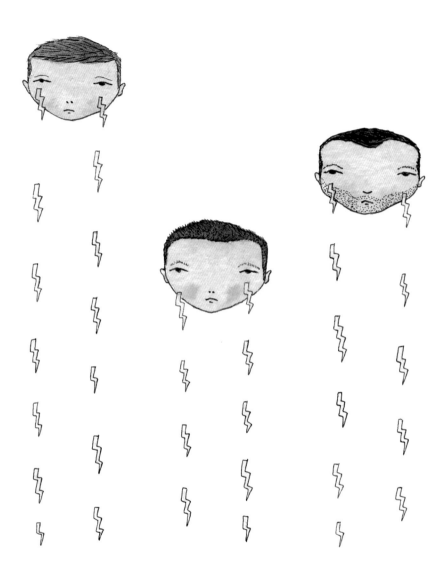

our tears are made of lightning

Why did you draw me on this side? I want to be on the other side. It's nicer over there.

too bad.

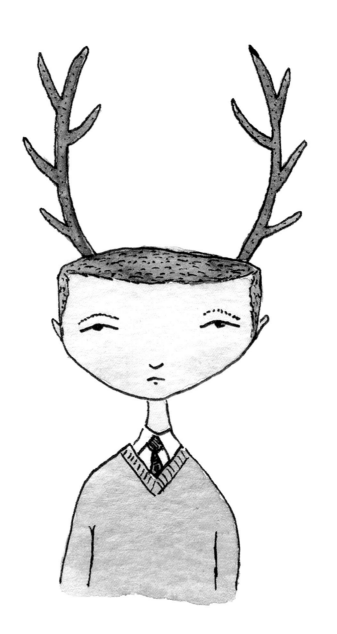

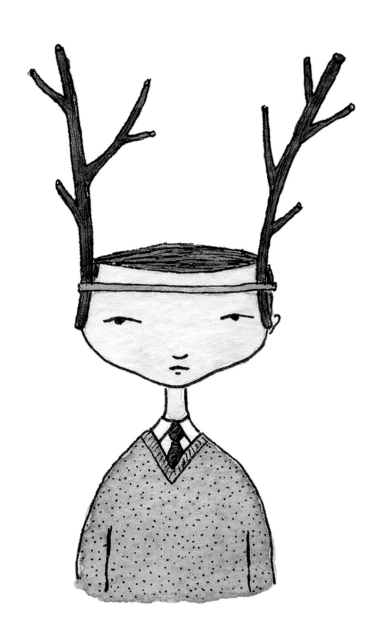

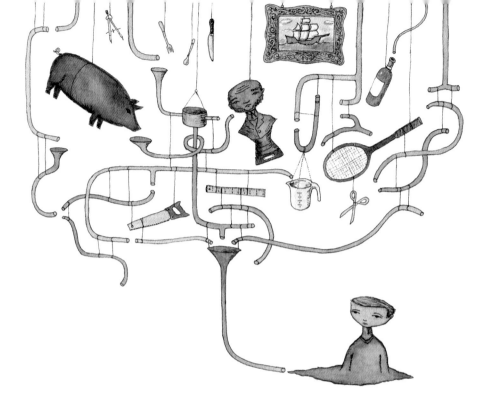

AFTER THE EXPERIMENT:
ALL THAT WAS LEFT OF DR. PICKERING.

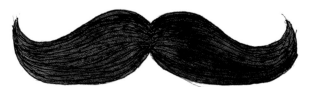

fake mustache made with horse hair

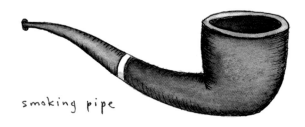

smoking pipe

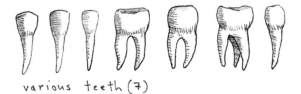

various teeth (7)

ELEMENTS REQUIRED TO CAST SPELL #786
FROM THE BIG BOOK OF COMPLICATED CURSES.

two and
a half
bones

bucket
full of
melted snow

cold
toast

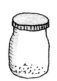

shaved off
eyebrow
in a jar

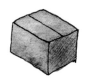

box of
stale
air

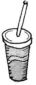

root
beer

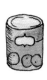

can of
peaches

photograph
of
berries

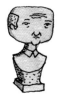

bust of an
obscure
historical
figure

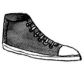

size 13
shoe

four
French
cigarettes

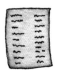

list of
Armenian
words

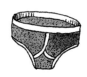

fifteen
year old
underwear

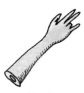

prosthetic
arm with one
missing finger

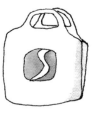

plastic bag
from Safeway

tinker toy

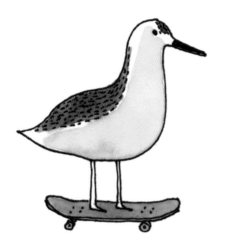

the world needs more
skateboarding sandpipers.

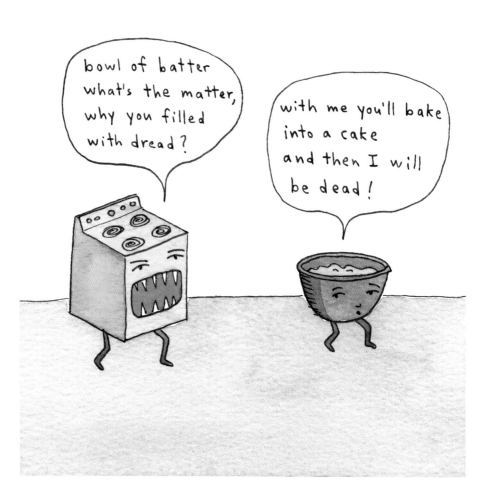

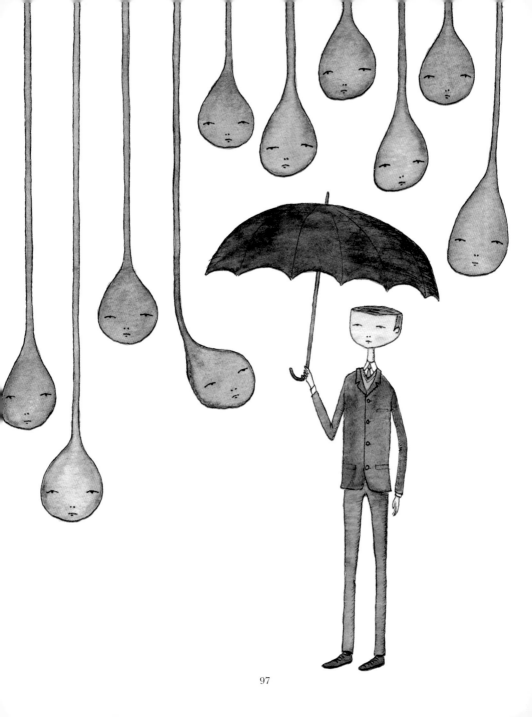

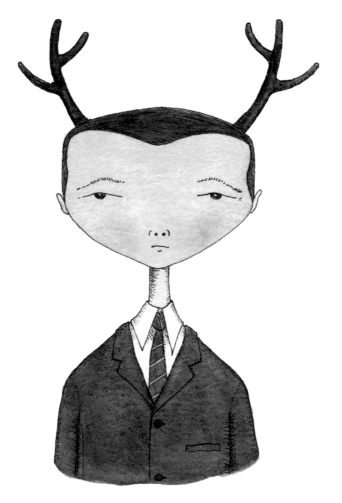

He felt that his antlers were inadequate.

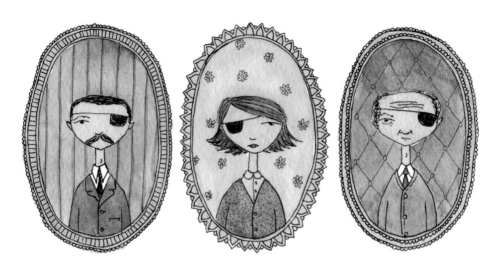

The van der Woodsen family,
shortly after the dessert fork incident.

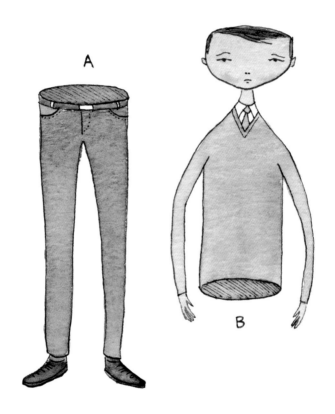

attach A to B and
everything should be peachy.

there are days
when I wish
I could wear
one of these
around my
neck.

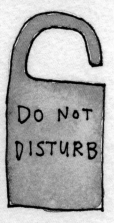

DO NOT
DISTURB

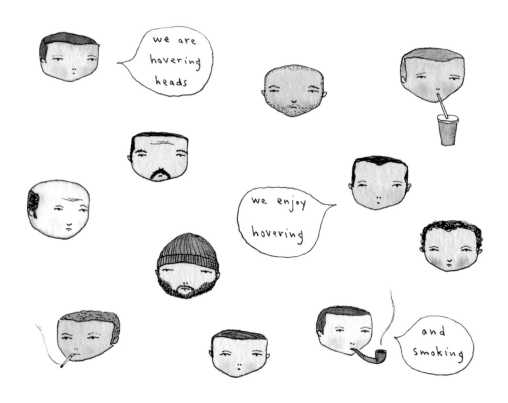

FUNNNY

spell it like this

from now on.

I like to draw
these. not because
they are
old school,
but because they
are more
interesting to draw
than iPods.

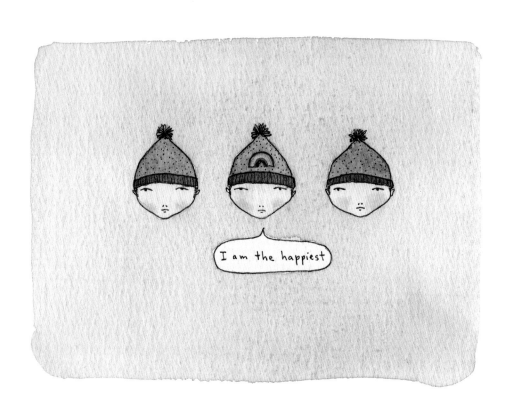

PROSTHETIC ARM AND
SOUVENIR SHOT GLASS
FOR SALE

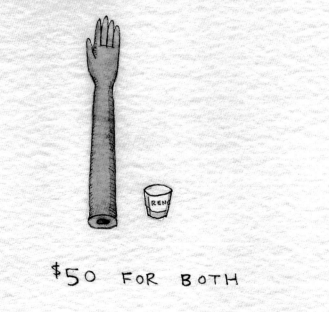

$50 FOR BOTH

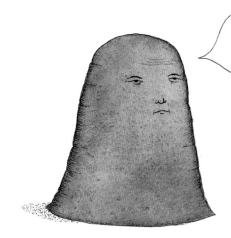

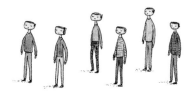

You shall worship me, and fetch me things, since I have neither arms nor legs.

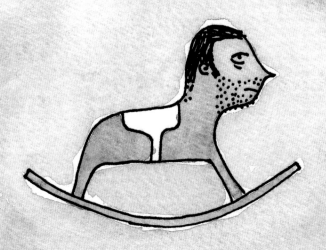

the children
were advised
not to play on
the rocking horse.

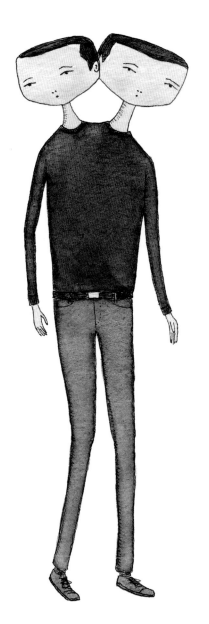

perhaps
two heads
are not
better
than one.

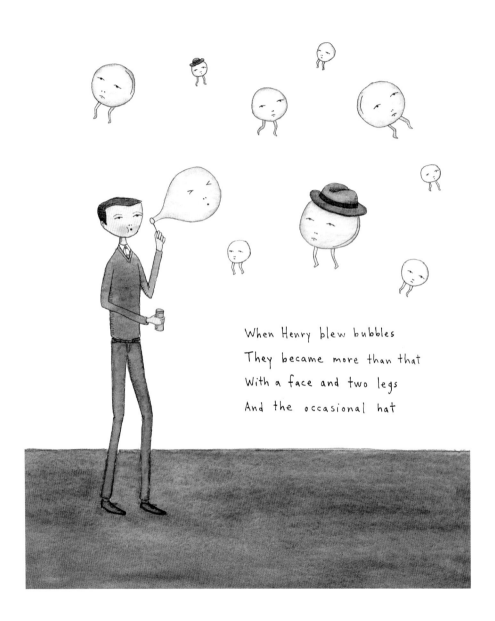

When Henry blew bubbles
They became more than that
With a face and two legs
And the occasional hat

RUGS FOR SALE

Buy the rug that is shaped like a bolt of lightning. It is better because it is shaped like a bolt of lightning.

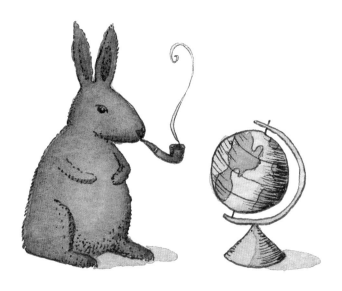

unbeknownst to most,
the world is completely
controlled by a single
pipe smoking rabbit.

Serious Drawings on sticky notes

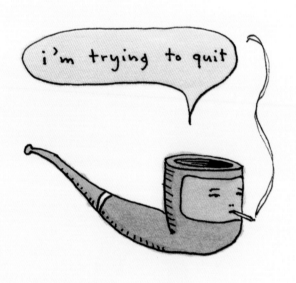

world famous
drawing

hundred dollar
haircut

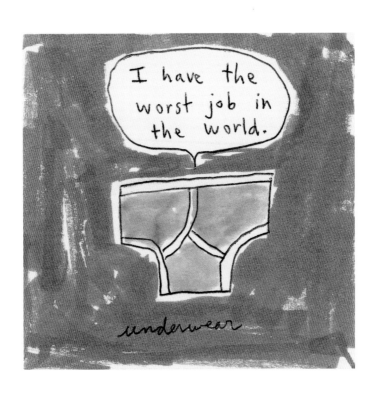

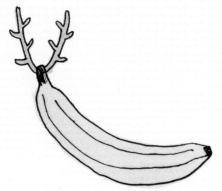

the antlers trend
continued to gain
momentum, until even
bananas wore them.

GROW

SIDE BURNS

ALL THIS AND MORE

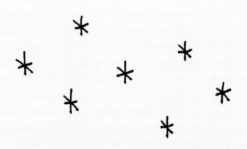

when you run out
of stars, you can
always use asterisks.

I am
truly
blessed

FUCK ART

LET'S BE

HEDGE FUND

MANAGERS

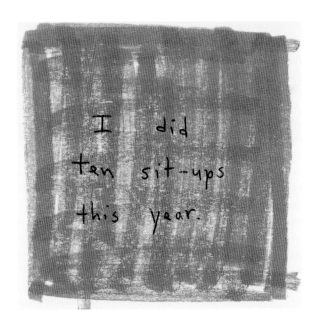

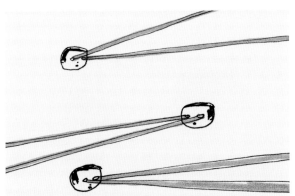

They were heads without bodies.
But when you have laser eyes,
you don't really need a body.

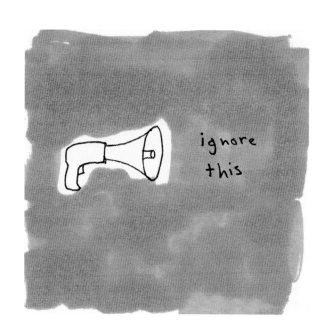

ignore
this

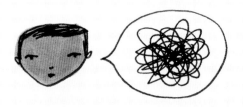

(He is talking about
tangled rubber bands)

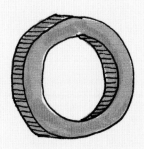

IS FOR

OMFG

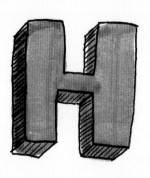

IS FOR

HOLY CRAP

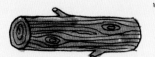

"free
bark
included"

LOG FOR SALE

- house trained
- won't rust
- floats
- saw it into boards,
 make a table
- turn it into paper,
 print a book on it
- burn it to keep warm

LET'S PRETEND TO ROCK

the world needs more
opera-singing boxes
of detergent.

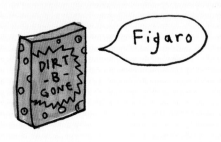

this one
is better.

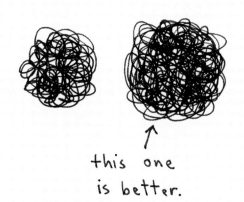

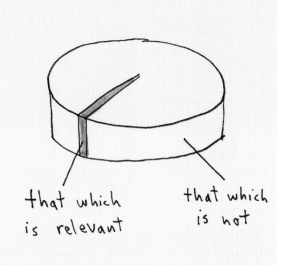

that which
is relevant

that which
is not

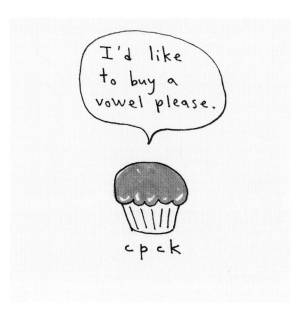

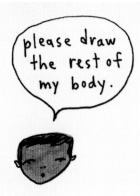

No.
I'm too
tired.

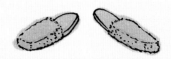

Queen Elizabeth II's
mucking-about-the-house
slippers

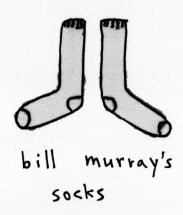

bill murray's
socks

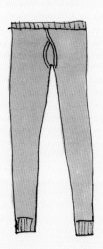

Prince
William's
long
underwear

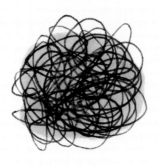

portrait of
a zeitgeist

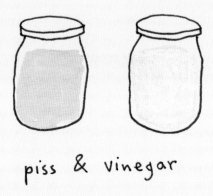

piss & vinegar

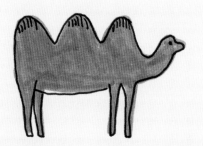

our camels are better

boneless drawing

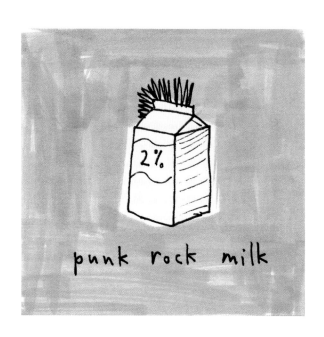

punk rock milk

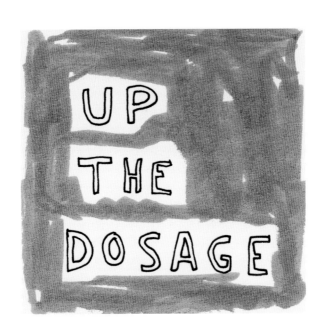

HONK

if you are
compelled
to do so.

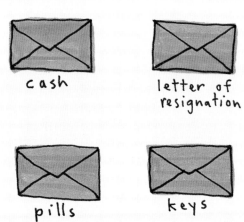

cash

letter of
resignation

pills

keys

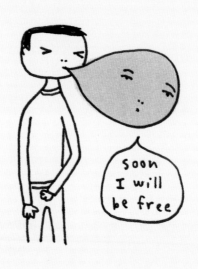

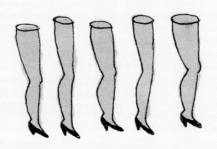

we offer lovely black shoes

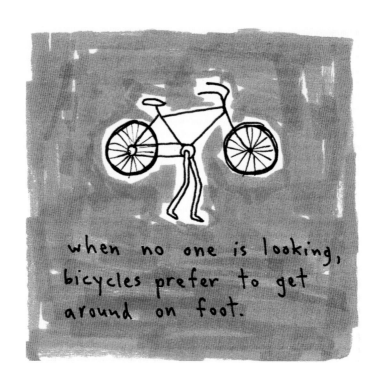

when no one is looking,
bicycles prefer to get
around on foot.

Hey look! A list of images

A GHOST'S SCHEDULE

MONDAY: Scare the crap out of people
TUESDAY: Scare the crap out of people
WEDNESDAY: Scare the crap out of people
THURSDAY: Scare the crap out of people
FRIDAY: Scare the crap out of people
SATURDAY: Pick up dry cleaning
SUNDAY: Rest

Marc Johns grew up in the Eastern Townships of Quebec, Canada, in the small town of North Hatley, where he had plenty of time to draw. He received his Bachelor of Arts with Honors in Fine Arts from Bishop's University. He draws almost daily, and has been for as long as he can remember.

In October of 2006, Johns began sharing his artwork online, posting new work on a regular basis. His humorous, witty and thought-provoking drawings were quickly embraced, and earned him a fast-growing community of fans around the world. The rapidly expanding exposure has led to appearances in books and gallery exhibitions, features in magazines, commissions on CD covers, and a generous amount of attention on blogs. Johns continues to share his prolific output online.

He lives and works in Victoria, BC, Canada with his wife, two boys, and a drawer full of pens.

Acknowledgements

This book is affectionately dedicated to Kristen, my wife and best friend. Your never-ending encouragement, patience and monumental support keep me moving forward. Your intuition and sharp instincts help me find my way through the fog. I would be a wondering fool without you. Thank you.

I would also like to thank all the good people online who sent e-mails, left comments and blogged about my work, in particular the terrific communities on Vox.com and Flickr.com. Thank you for your support, and for spreading the word to the far reaches of the internet. I am humbled and grateful.

Artwork by Marc Johns
Editorial coordination by Christina Burns
Design by Robb Ogle
Cover design by Jenene Chesbrough
Introduction by Carolina A. Miranda
Translations by Carmen Berelson (German) and Helena Solodky-Wang (French)
Photographic retouching by Greg Irikura

Published by teNeues Publishing Group

teNeues Verlag GmbH + Co. KG
Am Selder 37, 47906 Kempen, Germany
Phone: 0049-(0)2152-916-0, Fax: 0049-(0)2152-916-111
e-mail: books@teneues.de
Press department: Andrea Rehn
Phone: 0049-(0)2152-916-202
arehn@teneues.de

teNeues Publishing Company
16 West 22nd Street, New York, N.Y. 10010, USA
Phone: 001-212-627-9090, Fax: 001-212-627-9511

teNeues Publishing UK Ltd.
York Villa, York Road, Byfleet, KT14 7HX, Great Britain
Phone: 0044-(0)1932-4035-09, Fax: 0044-(0)1932-4035-14

teNeues France S.A.R.L.
93, rue Bannier, 45000 Orléans, France
Phone: 0033-(0)2-3854-1071, Fax: 0033-(0)2-3862-5340

www.teneues.com

ISBN 978-3-8327-9314-2

Printed in China

Bibliographic information published by the Deutsche Nationalbibliothek.
The Deutsche Nationalbibliothek lists this publication in the Deutsche Nationalbibliografie;
detailed bibliographic data are available in the Internet at http://dnb.d-nb.de

teNeues Publishing Group
Kempen
Düsseldorf
Hamburg
London
Munich
New York
Paris

teNeues